Alison Britton: Ceran

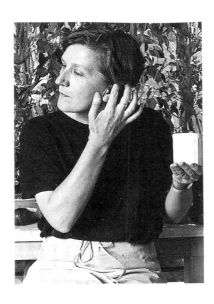

3 of these?

last one = little. also handle?

plaster
first =
slip painters?

slit

bottom on first.

chunky shout

mugs.

Alison Britton

Ceramics in Studio

Tanya Harrod

Bellew Publishing

Aberystwyth Arts Centre

First published in Great Britain in 1990 by Bellew Publishing
Company Limited in collaboration with Aberystwyth Arts Centre

Bellew Publishing Company Limited
7 Southampton Place, London WC1A 2DR

This book was published on the occasion of the touring retrospective
exhibition of Alison Britton's work, organised by Aberystwyth Arts
Centre and with additional funding from: Crafts Council of Great
Britain; West Wales Art Association and Welsh Arts Council
Touring fund

Designed by Ray Carpenter

ISBN 0 947792 66 X

Title page: drawing 1980-1

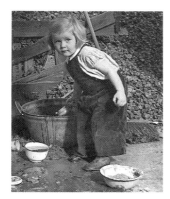

Alison Britton aged two and a half

Opposite: Alison Britton aged eighteen working
on Philippa Threlfall's mural at Leeds and
Bradford airport

Contents

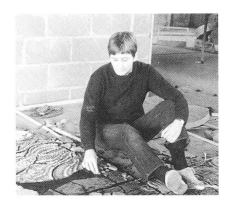

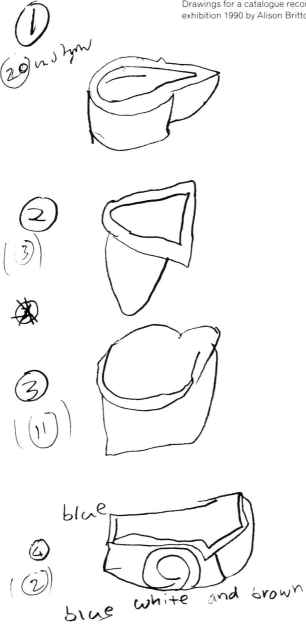

blue

blue white and brown

SINCE THE EARLY 1970s Alison Britton has worked as a potter. But in 1982 – and this makes matters more complicated – she also became an apologist for her generation: a writer. In *The Maker's Eye* catalogue of that year she attempted to articulate and make sense of the curious *frisson* of visual shock provoked by the objects then being made by her contemporaries: ceramicists like Elizabeth Fritsch and Carol McNicoll, by a metal worker like Michael Rowe, by the glass artist Steven Newell. All the selectors for *The Maker's Eye* wrote explanatory essays, but it was the two potters, Alison Britton and Michael Cardew, who argued their respective corners with the most clarity and conviction. Indeed, in a curious way the two essays are interdependent, mirroring one another.

Looking at old installation shots of that memorable exhibition it is clear that most of the makers selected by Alison Britton (many of them former contemporaries at the Royal College of Art) were conducting a series of investigations into a whole range of thoroughly domestic objects: bowls, jugs, boxes, jars and

7

so on. These things were viewed with the kind of dissecting eye that had been educated by the paintings and small sculptures of early modernism. Naturally there was an element of subversion in all this: the deconstruction of the object was not what was expected of the crafts at the start of the 1980s.

The roots of those expectations lay in a mass movement in pottery, inspired by the writings of Bernard Leach, that had begun to flourish immediately after the war. It was, surprisingly perhaps, insistently concerned with the creation of functional pottery, with what amounted to mass production by hand of useful objects for lowish prices. In this popular form it was in many ways a rather philistine movement – rich in hopes for a better future but rather short on artistic ambitiousness. At the time of *The Maker's Eye* this branch of the studio ceramics world was only just beginning to falter.

It would, of course, be wrong to suppose that Alison Britton and others of her generation were the first to pose an alternative to the Leach aesthetic. Indeed it was a friend and colleague of her father, the New Zealander William Newland, who led a bold counter-movement immediately after the Second World War. Working in earthenware and decorating in tin glaze, Newland, his wife Margaret Hine, Nicholas Vergette, James Tower and others threw and altered, made majestic vessels and figurative groups. They were inspired by Picasso's ceramics, by their reading of the Italian design magazine *Domus* and by that marked post-war affection for all things Mediterranean. The Picassettes (as Leach derisively dubbed them) formed an alternative urban camp, as did Hans Coper and Lucie Rie. Then by the early 1960s we find a strong sculptural strain in art-school-based British ceramics – with the austere stoneware of Gordon Baldwin, Ruth Duckworth, Ian Auld, Dan Arbeid and Gillian Lowndes, all potters connected with the Central School.

In contrast Alison Britton, Elizabeth Fritsch, Carol McNicoll, Jacqui Poncelet, Andrew Lord and Richard Slee were to take up a position that was simultaneously more decorative and more elusive and ironic. On the one hand the ambition to make abstract sculpture in clay was set aside. This was replaced by a playful yet searching look at everyday forms. While for instance Ruth Duckworth had retained the earthy hues associated with stoneware and with Bernard Leach, Elizabeth Fritsch was to pioneer a whole range of light bright colours. As a result,

8

her contemporaries, whether working in earthenware or stoneware, nearly all became sensuous skilled colourists and mark makers. In addition, the group (and in 1982 they could still be seen as a group) had all looked at American Funk ceramics, rejecting much of the grossness but borrowing some Funk carefree oblique humour. Early jugs by Alison Britton, origami-like plates by Carol McNicoll, the 'Still Life' coffee sets made by Andrew Lord all played with notions of usefulness. Alison Britton in particular employed Leach's carefully developed language of form – the generous handle, the notable beak or lip, the curvature of belly to shoulder – with a kind of semi-satirical *élan*. But her pots clearly belonged to some quite other world – one where time could be spent handbuilding each piece, where the figurative and patterned decoration was both 'primitive' and knowing, where technique was kept as simple and as stripped-down as possible.

Looking back over the past two decades we can see how that initial poised position – creating what Alison Britton with an enviable precision was able to identify as 'two-faced' objects – began to seem unsatisfactory. The group matured, changed and artistically drifted apart. Although Alison Britton has continued to reiterate the ideas she expressed so eloquently in *The Maker's Eye,* those ideas are no longer strictly relevant to her own work. Nor should we have to run through the other arguments invoked to give a context to ceramics as an art form. It seems overly apologetic to draw those helpful parallels with Meissen, Sèvres and maiolica and with that whole range of costly European non-functional ceramics that Philip Rawson has identified as 'treasure' in his classic handbook *Ceramics.*

Alison Britton's work has greatly altered over the past ten years. It has become less keen to please, and tougher. Because she has abandoned figurative narrative drawing, each pot is less of a commentary and instead we are presented with a sequence of objects that develop, solve or abandon formal problems. Take one of the finest pieces of recent years: the large Double Pot which is now in Hove Museum and Art Gallery. On one level the Hove pot is 'about' vessels – the jug and the bowl in this instance. Mysteriously and unproblematically, the bowl and jug are merged into one object. But the juxtaposition is not intended to be witty or entertaining. Instead they are merged with a sense of a grand inevitability. In

fact the bowl and jug qualities do not after all seem to be the key to what is going on here. The lack of reference to a domestic mood suggests that purer forms – the cylinder and the triangle, for example – are being investigated. Then there is the way in which the piece is painted. We know the degree of relaxed spontaneity with which that kind of bold gestural mark has to be made. It is the antithesis of decorative pattern making. To sum up: there is an investigation of basic as opposed to domestic forms; there is lovely gestural painting. As a result we have a pot that takes up the light like a painting and a pot that commands the ambient space like a sculpture. In short, we have painting combined with constructed sculpture. Maybe only ceramics can accommodate both disciplines.

Perhaps unsurprisingly, the collectors of these late pieces own them in lieu of sculpture and demand from them all the problematic resonances that only sculpture can provide. It has not been easy for Alison Britton to arrive at this point in her career as the main body of the book – the chronology and the illustrations – makes clear. The chronology juxtaposes extracts from her finished, polished and sophisticated pieces of writing and my transcriptions of our tape-recorded discussions. The two voices complement each other: one is cool, logical and confident – the writer; the other is less sure, more searching and reflective (and very difficult to capture and to put into cold print) – the artist. The pictures tell a rather simpler story: that of a progress, a development into an abstract art of engaging complexity.

Alison Britton: Techniques

The techniques that I use are in themselves very simple and consistent. At the moment, the clay is always a plastic buff body that is meant for stoneware, but I fire it to a high earthenware temperature a little above 1180°C in the first firing.

The clay is rolled out by hand like pastry in big sheets on pieces of canvas. I get three sheets out of one 25 kg bag of clay. A texture is introduced in places on the surface by rolling in small scrapings of dry clay to make 'disturbed' areas, or impressing marks with a rubber roller that may have been meant for butter. Then a casual drawing is done in slip of a strong colour, using a trailer, which is like a wet form of cake decoration. When this is dry enough, it is covered with a whole surface of slip of a light colour, painted on with a flat brush. I intend the slip to bring slight relief and a richer surface as well as colour. Various different brushes are used as well as trailers and finger painting. The next layer is another drawing on the all-over surface, often done with a trailer for higher relief. I have only four or five colours mixed up at any one time.

When the slip is dry enough, the sheet is turned over and something complementary but different is done on the other side. The pots are assembled from pieces cut from these sheets when the clay is leatherhard; hard enough to sustain the form, and to be pressed into secure joints from wall to wall. Deep curves have to be set up and supported while still too soft to join. I try to be very unwasteful with the sheets – frugality can help to determine the form of a pot, as well as a response to the painting in the way that the lines are cut. Once the pot is put together, losses of the slip surface that are necessary to making strong joints are made good. I do this as part of a reassessment of the painting as a whole, making sense of the initial marks in terms of the new three dimensional form and not as a retouching process.

Marks are sometimes scratched through the slip when the pot is nearly dry. (After glaze firing, slip looks opaque where it is thick, and reveals underlayers where it is thin.) After biscuit firing, the painting is usually developed with transparent pigment – thin washes and some stronger lines of underglaze or metal oxide. Then the glaze is applied. The insides of forms are normally poured, and the outsides sprayed. Plate forms have both sides sprayed. The glaze is Dora Billington's recipe for a matt transparent earthenware glaze using Lead Sesquisilicate, a fritted (insoluble) form of lead. I fire it to 1100°C. I acquired the recipe at the Central School in the 1960s.

Pots occasionally have supplementary glaze firings if they are not pleasing at this point. As a last resort, they can be sandblasted to remove unsatisfactory painting, then repainted and reglazed.

The kiln is old, ordinary and electric. It is not very large and holds three or four pieces usually in one firing. The biggest pots I make, approximately 50 cms finished height, almost scrape the roof.

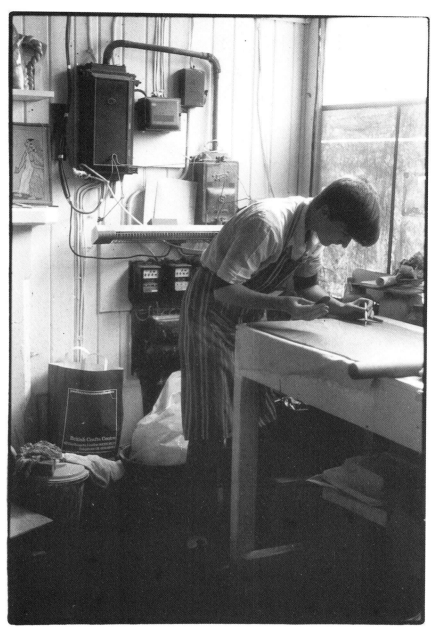

Alison Britton at her King's Cross workshop in 1977

Alison Britton: a chronology

An extended chronology compiled by Tanya Harrod and incorporating published material and conversations with the artist during July 1990.

Alison Britton in her present studio, 1987

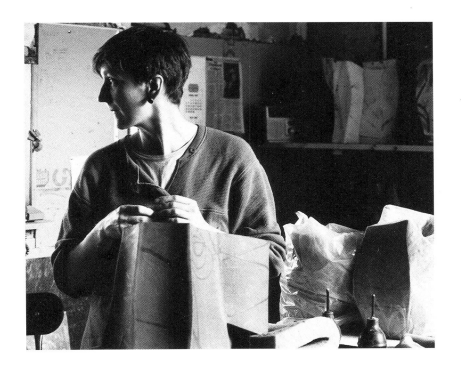

'*I woke one morning and saw two jugs on the table;
without any mental struggle I saw the edges in relation
to each other, and how gaily they almost seemed to ripple
now they were freed from this grimly practical business
of enclosing an object and keeping it in place.*'

Joanna Field (Marion Milner),
On Not Being Able to Paint, 1950

1948 Born in Harrow, Middlesex. Father James Britton – 'Jimmy' – a teacher, publisher and pioneering educationalist. Mother, Roberta, taught at the same co-ed grammar school before the war – 'my father walked over some scenery my mother had painted for the school play. At that stage, women had to leave teaching when they married.'

'A protected, peaceful childhood, with one sister.'

1952–66 North London Collegiate School, a day school for girls with a remarkable art department headed by Peggy Angus.

'It had, on the other side of the pond, a separate encampment of people who weren't being academic – there was a dedicated art staff, people like Moy Keightley, who were all practitioners. In particular I remember a wonderful teacher of pottery: Phillipa Threlfall. She did ceramic murals and I helped put one up at Leeds and Bradford airport during one summer holiday.'

Aged fourteen gets to know her father's colleague William Newland, a painter turned potter, part of the group dubbed Picassettes by Bernard Leach. Newland was teaching at the Institute of Education, doing for clay what Marion Richardson had done for the teaching of painting and drawing in schools.

'At half-term when Jimmy was working at the Institute of Education we would go up with him and either hang around the British Museum or, as on one occasion I remember, spend the whole of half-term working in the pottery in the Institute with Bill.'

1966 Leeds College of Art – Foundation Year, a course with a Basic Design approach originally set up by Harry Thubron.

'We spent most of the year on bombsites drawing with thick charcoal. They tried to talk me out of throwing myself away on ceramics.'

1967–70 Central School of Art and Design. The ceramics department was run by Gilbert Harding Green, with the heavy work done by Bonny van de Wetering and her husband John Colbeck. Gordon Baldwin was a favoured tutor. Classes in metaphysical poetry and the nineteenth-century novel given by A. S. Byatt. Fellow students included Richard Slee and Andrew Lord.

'I can't remember much about the Central. The mood was certainly anti-Leach. We used bright colours and didn't do much stoneware. There was a good deal of throwing and turning. A lot of piercing was going on – pots with holes in them and bright shiny glazes and lots of sgraffito – it was all quite decorative. I particularly liked Gordon Baldwin's teaching day. He used to arrive in his Landrover with a piece of work that he was doing, lug it upstairs to the studio and teach while he was working.'

Au pair in Helsinki during the second year. Made a visit to the Arabia factory – very impressed by the Utopian arrangements there.

'It was a good course, very practical. I think that I felt quite well equipped at the end of it. I could certainly *do* lots of things, I knew a great many techniques. But it didn't give me a sense of what my contribution was going to be. I just had quite a few skills. I couldn't do accurate repetition throwing. And I think at that stage I knew that round was not as interesting for me as irregular. That is what put me off working harder at throwing: I wasn't happy with the end result. The handbuilding I did on Gordon's day was far more satisfying. It didn't occur to me then to

throw and alter like Lucie Rie or Betty Woodman. I took it very straight and it seemed uninspiring.'

1970–3 Royal College of Art – School of Ceramics and Glass. Fellow students included Carol McNicoll and Colin Deeks together with Jill Crowley and Jacqui Poncelet in the second year and Glenys Barton and Paul Astbury in the third year. Elizabeth Fritsch had left but was still working in the college. 'Colour was the exciting thing about Liz's work. She had tested some very unusual Piero della Francesca-like colours.'

During the first year took up the offer of 'a peaceful attic room' in her aunt Claire Winnicott's house following the death of Claire's psycho-analyist husband Donald Winnicott. Reads his *Playing and Reality* – 'Very important for me at that time because it discusses creativity and its roots.' Read Arthur Koestler's *The Act of Creation*, Bernard Rudolfsky's *Streets for People* – 'This analysed the kind of architectural space that suited people, unconventional thought at the time!' – and Germaine Greer's *The Female Eunuch* – 'We developed a nice level of outrage.' Rejected Morse Peckham's *Man's Rage for Chaos* – 'An awful American cult book everyone was battling through.'

Exhibition at the Forum Gallery, Brighton, during first term. Made 'figurative primitive joky toy theatres'. Work done in secret away from college.

Photography taken up. Surveyed architectural details with Eduardo Paolozzi's assistant. Much moved by the tiled stoves in the V&A – 'decorative and functional'.

'With a certain amount of encouragement from the staff, I decided that architecture was a good niche. I went to Stoke-on-Trent for a week and did underglaze painting at the Spode factory and watched them do tube lining at Poole. My degree show was practically all tiles with just a few compensatory warmer handbuilt pieces like the 'Survivor's Cup' and 'String Cup'. Fresh encounter with family friend Quentin Blake who taught in the School of Illustration. Links made with that department.

'I was trying to do a pen-and-ink equivalent on tiles which meant I got

1. 'String Cup' 1973 coiled and
pinched earthenware cup height 10 cms
saucer diameter 20 cms

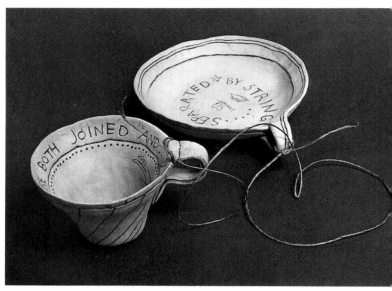

3. 'House Box' 1973 slab-built earthenware
height 25 cms

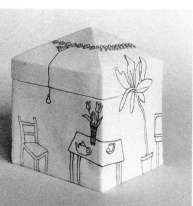

2. 'Box' 1973 slab-built stoneware
height 15 cms

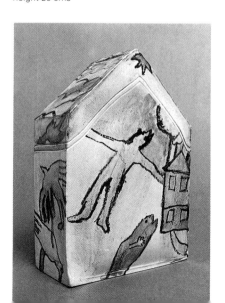

18

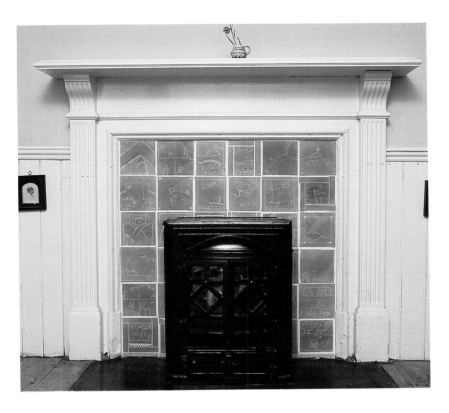

4. Tiles for a fireplace commissioned by Marion Milner 1973

through a lot of mapping-pen nibs using manganese oxide which is not as controllable as ink: it bleeds and blurs when you fire it. Washes and underglaze were also put on, a sort of watercolour equivalent. I made an alphabet which people quite liked.'

Quentin Blake, writing in the catalogue *The Work of Alison Britton* (Crafts Council, 1979): 'The first piece by Alison Britton that I owned was made by her while she was in the School of Ceramics at the Royal College of Art. It's a little ceramic box, with a lid roughly in the shape of a house. It's white and incised on it in brown lines is a drawing of the interior furniture. The television set bends *backwards* round one corner. Though it's a small piece it has many of the characteristics of the artist's subsequent work: the wit, the angularity, the edgy drawing.'

'Hans Coper was the best tutor for me. I talked to him about once a week. At that stage he seemed like a person to whom you could say anything; in fact you found yourself saying more than you thought possible. I think it was only later that I seriously looked at his work or understood where it fitted in.'

Part of the final year was spent writing a short thesis entitled *Overlap* supervised by Nick Boulting, tutor in Design History at the Central School. Boulting put Britton in touch with Ernst Gombrich, who passed on photocopies of his Wrightsman Lecture notes (published eight years later as *The Sense of Order*).

'I went away with those notes and there is such a lot in them that I still hold in my head: the idea of the margin, of things on the edge having freedom to be significant rather than the thing in the middle. The way decoration is used to ease change – having triglyphs to represent wooden beam ends when Greek temples began to be built in stone, the artifice of electric coals.

'My first job, while still a student, was for Marion Milner. She was an exciting, difficult person. I installed the tiles in the fireplace – they were funny little drawings – and she rang me to say, "I can't bear it. I'm going to paint over them." My heart sank. Then she rang up again and said, "I think it's wonderful. I realize I just wished I had done them myself."'

Years later read Marion Milner's psychoanalytic writings: 'Part of her philosophy of life is that things which slip in at the side are whole, that it's no good being too focused and challenging. The oblique is more potent than the head-on.'

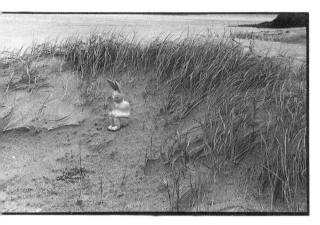 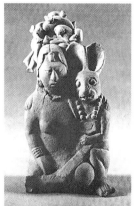

5. 'Rabbit Box' 1974 coiled and pinched earthenware height 21.5 cms

6. 'Woman accompanied by a rabbit' from a catalogue of the Maya Sculpture Collection of Manuel Barbachano Ponce

1973–6 Moved to shared workshop at $401\frac{1}{2}$ Wandsworth Road with Carol McNicoll. Concentrated on tile commissions. Gradually came to dislike the concomitant 'bathroom problems'.

Sees the catalogue of an exhibition by Robert Hudson and Richard Shaw held at San Francisco Museum of Art in 1973. 'They were usable objects wearing the disguise of their decoration to the extent that the decoration had become the thing itself' (Alison Britton, 'Sèvres with Krazy Kat', *Crafts* 61, March/April 1983).

'In 1974 I went to the States for the first time, with Steve [Newell]. I looked at the buildings mainly. Sometimes the context seemed odd – like in Nantucket where the sands blow over the road and houses look as if they're on a beach. We visited a place called Ephrata Cloister in Pennsylvania with an extraordinary wooden building with many floors and many

21

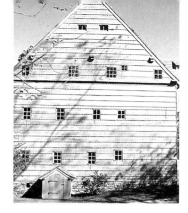

7. 'Ephrata Cloister, Pennsylvania' photograph taken by Alison Britton on a visit to North America in 1974

windows. The scale is hard to read – you can't tell if it's a vast building with normal-sized windows or an ordinary building with tiny windows. I very much like the weathering and ageing of these wooden buildings. And the detailing – it all seems quite relevant to my work.'

From 1974–7 teaches at Portsmouth School of Art.

In 1976 starts teaching at Harrow School of Art – 'The students were strong people who had done different things. I taught them drawing. Occasionally I was allowed to look at their pots.'

1975 Moved to a workshop in King's Cross shared with Jacqui Poncelet.

'I had more private space there because it was on two floors. I used it as a shift in general. I'd done some work for collectors called Catleugh. They knew Tim Boon at Amalgam and he asked me if I wanted a show. And that was the beginning of making things other than to commission. I had gradually come to feel less and less satisfied by the flatness of tiles, the feeling that I was being witty and unusual in two dimensions.'

1976 Solo show at Tim Boon's Amalgam Gallery – a mixture of jugs and tile pictures.

'The first jugs were the Amalgam ones. The red one with the girl on it is very early. I made it when I was teaching flower-arranging ladies. It wasn't right until I painted it. The handle was horribly thin but because I painted chequers all over it, it looks thicker. I like that: the way a two-dimensional surface can change the shape and re-emphasize things.

'There was a group of four jugs in that show. I wanted them to be

22

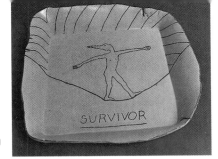

8. 'Survivor Plate' 1973 press moulded approximately 30 cms square

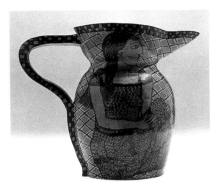

9. 'Red Jug' 1976 coiled earthenware height 30 cms

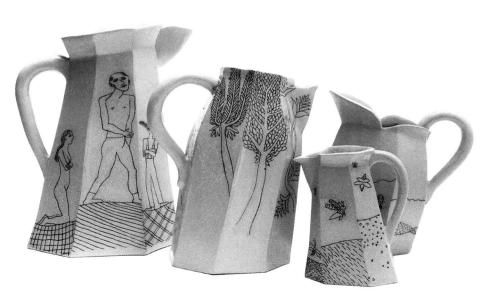

10. 'Four Jugs' 1976 slab-built earthenware from height 28 cms to height 17 cms

11. 'Fish Jug' 1976 slab-built earthenware
height 30 cms

12. 'Jackal Bowl' 1976 slab-built earthenware
approximately 28 cms square

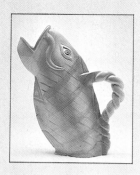

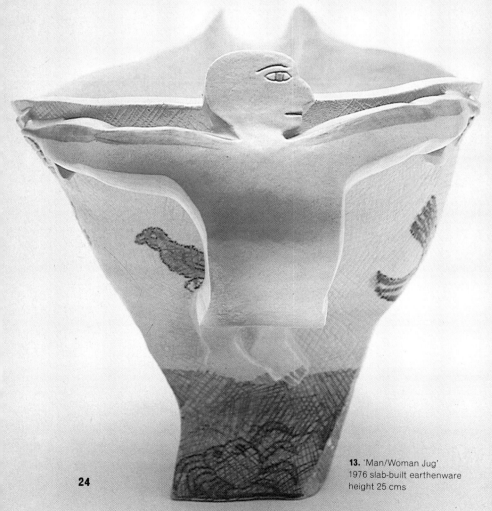

13. 'Man/Woman Jug'
1976 slab-built earthenware
height 25 cms

different elements of the natural world. One had insects as a subject, one had people, the other two had fishes and birds. They were simply constructed, naked, plain, with drawing scratched on to them – black underglaze painted messily over the top, scraped clean and biscuit fired and glazed. They were not unlike the sgraffito things I'd done at the Central, but with more of a theme, more intense about the subject matter. And that was the beginning of the jug being my vehicle.'

1977 Moved to 7 Roden Street off the Holloway Road. Daughter Laurie born in December. Took part in *Ceramics and Textiles*, a British Council touring exhibition to the Middle East and in *New Pottery*, an Eastern Arts touring exhibition from which the Crafts Council bought three pieces.

1978 The beginning of strong links with galleries in Holland with two shows there: a shared exhibition with Jacqui Poncelet at Galerie het Kapelhuis and *Five British Potters* at the Princessehof in Leeuarden.

'Those two jugs in the V&A – with a flat back joined to a single curve of clay. That structure suggests two different elements juxtaposed. The bit at the back carried natural imagery which creeps round to the front where there is mechanical pattern.'

Contributes an essay, 'In the Same Field', to the catalogue of the Elizabeth Fritsch touring exhibition *Pots About Music:* 'It is interesting how quite other than visual reasons for a form being the way it is can have such a strong visual result – another kind of resonance. It is as if a tangential sense of purpose frees and stimulates the imagination to some completely unforeseeable end. I feel the same kind of awe looking at these pots as at some ancient work when I do not know or understand the magical or mythical motives and am none the less moved.'

1979 Four exhibitions including *Jugs and Aprons* with Stephanie Bergman at Aberdeen Art Gallery. A solo show at the Crafts Council Gallery: *The Work of Alison Britton*, 14 November – 12 January 1980. This show had a remarkable sequence of pots with figurative drawing and

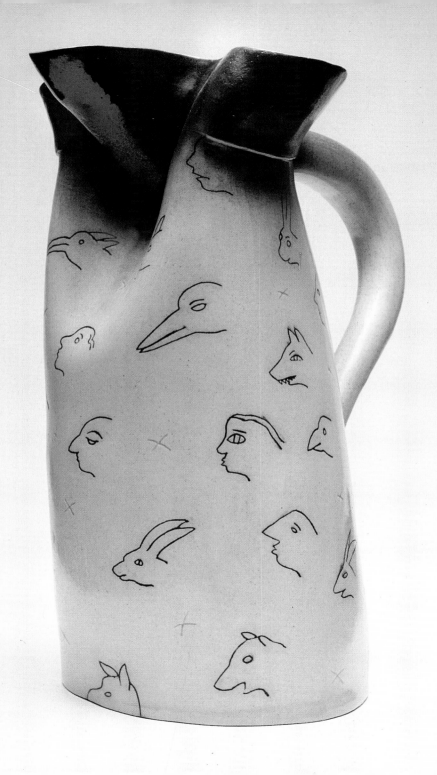

14. 'Jug with Profiles' 1977 slab-built
earthenware height 26.7 cms

15. 'Triangular Jug' 1979 slab-built earthenware
height 31 cms

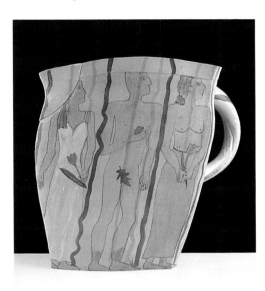

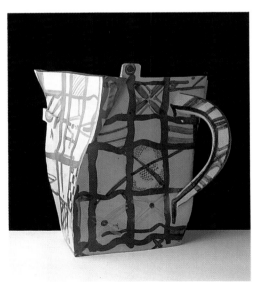

16. 'Big Green Jug' 1979 slab-built earthenware
height 31 cms

enigmatic poetic titles. There were also pieces that signalled the end of figuration as a form of decoration.

'I was conscious of gender at the time of the Crafts Council exhibition. There were quite a few pots depicting men and women in the show. I've often made reference to maleness and femaleness in pots, whether it's in the drawing or in the shape. I've not been aware of some of these references until afterwards. I think I drew fish and tulips before I recognized them as male and female symbols. But then I carried on, knowing that.

'I think that the 1979 Crafts Council show was the beginning of being non-figurative. That last figurative phase was a painful time and I didn't know how to follow it. The state I was in in life – everything was changing and so the work needed to change as well. I sometimes wonder if I lost a great deal. You are putting on one side some quite articulated stories if you stop being figurative. It felt like a development – that I didn't need them any more and it was somehow pithier to be abstract. I was becoming more sensitive to three dimensions and if you have a very strong feeling about the solidity of a form you can't draw a picture on it. The other strand was that I was becoming more interested in contemporary art – shifting from having been mainly nourished by the British Museum. It is very easy for our generation to respond to prehistory in art. It probably was difficult a hundred years ago but now early art seems very condensed, strong and uncontaminated and of course it connects with things to do with childhood. A turning point was seeing a show at MoMA of Pollock drawings [Jackson Pollock, *Drawing into Painting,* Museum of Modern Art, Oxford, April–May 1979]. There the idea of skeins and layers seemed so strong. Looking through layers to other layers became more exciting than the portrayal of something specific.'

1980 Three group shows including a second shared show with Jacqui Poncelet at Galerie het Kapelhuis.

'There was a gap when I didn't make anything and tried to write a book on tiles for Penguin. I made "Teaspot" when I came back from Italy. It's been described as "aggressively functionless". I'd never made anything

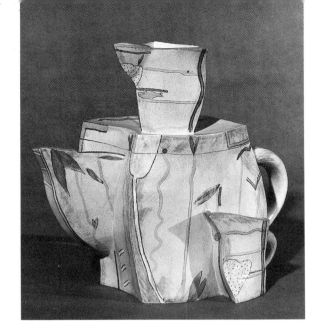

17. 'Teaspot' 1980 slab-built earthenware
height 40 cms

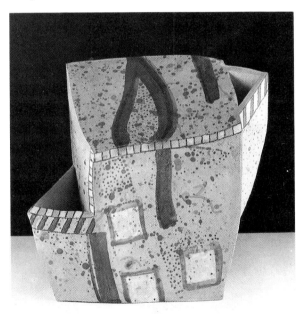

18. 'Covered Pot' 1980 slab-built earthenware
height 30 cms approximately

19. 'Predictable Crises' 1979 slab-built earthenware height 23 cms

20. 'Tulip Jug' 1982 slab-built earthenware height 27 cms

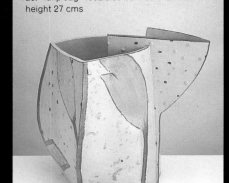

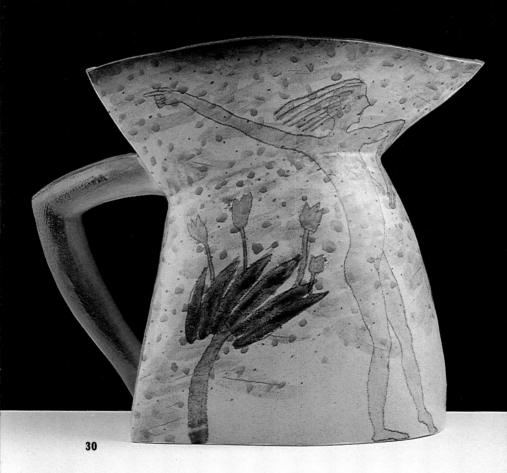

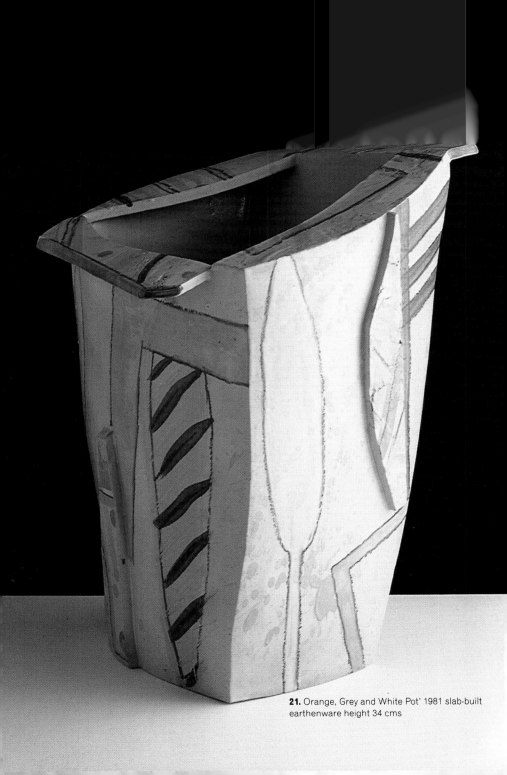

21. Orange, Grey and White Pot' 1981 slab-built earthenware height 34 cms

with a lid, mainly because I thought, "How boring if you can't see inside." That is why I had to have this other pot on the lid. That led on to the next series: pieces like that pot which looks like a house which is somewhere in Holland. It was challenging my prejudice, covering the top.'

1981 Two solo exhibitions and a group show in Belgium. A language of roughly painted geometric forms on handleless pots develops.

1982 Selects and introduces a section for the major show *The Maker's Eye* held in January in the Crafts Council's new galleries at Waterloo Place. Takes part in numerous other exhibitions, including a small solo show at the V&A Craft Shop. Daughter Lucy born in June.

'A "modern" novel is both made of, and about language. Some of the objects I have chosen are similarly self-referential, that is, they perform a function and at the same time are drawing attention to what their own rules are about. In some ways such objects stand back and describe, or represent, themselves as well as being. In the analogy with the novel "function" stands for "story" as the central context.

'However, I am not only concerned with this rather elusive category in my selection. I have chosen vessels or containers that are ordinary too, and to me supremely and powerfully so. I would like to make a comparison evident between "prose" objects and "poetic" objects; those that are mainly active and those that are mainly contemplative. To me the most moving things are the ones where I experience in looking at them a *frisson* from both these aspects at once, from both prose and poetry, purpose and commentary. These have what I call a "double presence".' (Alison Britton, *The Maker's Eye*, Crafts Council, 1982).

'Craftspeople – and the self-consciousness of that word is highly appropriate – are at their most pretentious when their work seeks to identify with painting and sculpture, whereas painters and sculptors invariably seem at their most innocent and exuberant when dabbling in the crafts' (From a review of *The Maker's Eye* by John McEwen, *The Spectator*, 23 January 1982).

22. 'Three pieces on a base' 1981 slab-built earthenware jug height 23.5 cms base 41.5 cms × 26 cms

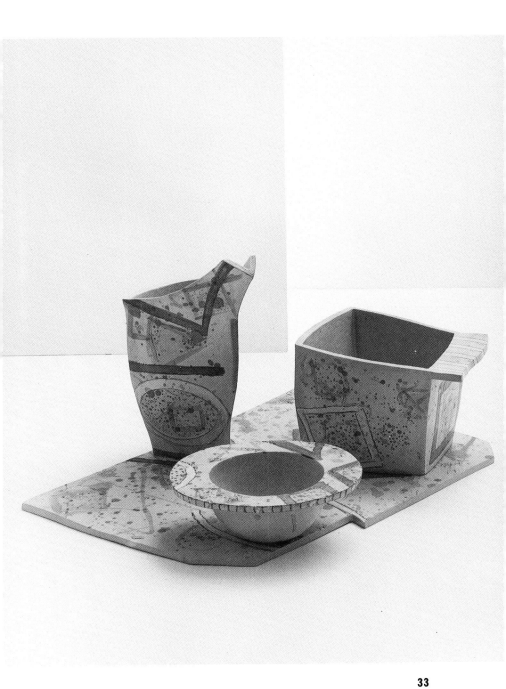

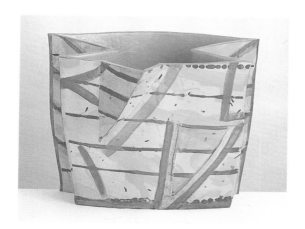

23. 'Yellow Zig Zag Pot' 1982 slab-built
earthenware height 25.8 cms

24. 'Jug and Bowl' 1981 slab-built earthenware
jug height 34 cms bowl height 18 cms

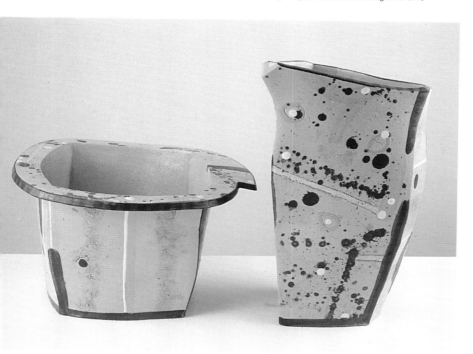

25. 'Intersected Pot' 1982 slab-built earthenware
height 28 cms

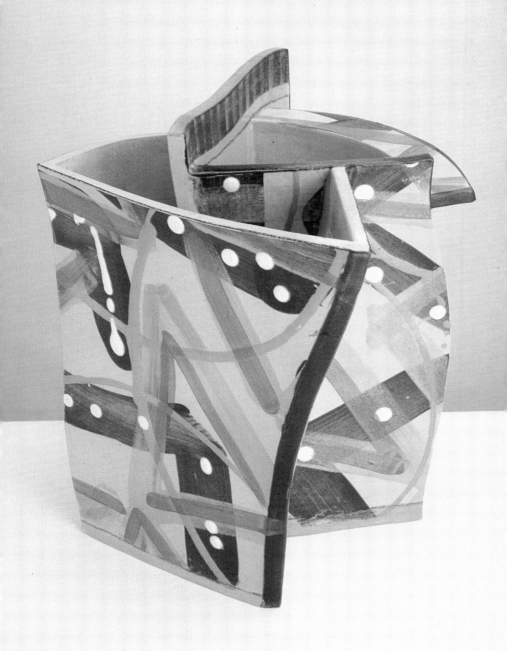

'The reviews of *The Maker's Eye* were interesting. Most were very positive but some fine-art critics seemed threatened by the blurring and overlap of fine and applied art. I was shocked that they couldn't see that there was any mileage in shifting the categories. They just wanted it to stay as rigid as it had been.

'It was the beginning of writing. That essay is the first thing I felt proud of having written. It was terribly clear to me that the act of writing brought out and clarified ideas which I didn't know I had. People like Jim Partridge, whose work appeared in several sections of the show, felt that it was right, that I had hit the nail on the head – which was very moving, that other people felt I had spoken for them.'

1983 Christopher Reid and Peter Fuller survey the Royal College of Art 'group' critically in, respectively, 'A Culture of Doodles' (*Crafts* 64, September/October 1983) and 'The Proper Work of the Potter' in the catalogue of the exhibition *Fifty Five Pots* held at the Orchard Gallery, Londonderry. Ironically, Fuller quotes extensively from the writings of Donald Winnicott and Marion Milner to sustain his case against 'these tiresome late-modernist excesses'.

A semi-collaborative show with furniture maker Floris van den Broecke is held at Aspects Gallery, London.

'We looked at each other's work in progress, with Floris giving me little drawings. We both picked up on the idea of squares, triangles and circles and he did it in a very perfect Dutch way and used three different materials in each table: rusted metal, glass, terrazzo, plastic flooring and so on. My things were also geometric but much looser. None the less the square, triangle and circle articulated the actual shapes and the way in which they were painted. There is a piece in the Stedelijk Museum in Amsterdam which is the best early example of that kind of thing and it was also practically the first double pot, inscribed with big bands of black. I believe that the double pot is the most important shape I've done – they set up strange reverberations – there is a lot of architecture in them and quite a lot of the human form.'

Begins to write leaflets for the British Craft Centre on a regular basis.

1984 Takes part in the *Black and White* exhibition at the British Craft Centre.

'The reason that piece is only black and white is that it followed work that was getting dangerously excessive. I was thinking – I'll keep the shape fairly complicated but I won't use colour. Tatiana [Marsden] suggested that I make something for the Black and White exhibition at the BCC. That was a trigger. I had two pieces in that and then I did about ten more. There is a very simple pattern with these parallel lines and zig-zags. These big swathes are done after it is put together, after the biscuit firing. Yes, there is a sense of danger. Quite a lot of the big marks are done with slip which you can't get off easily.'

Begins to teach at the Royal College of Art.

Lectures in Bratislava and Prague as curator of *Britska Keramika*, a British Council exhibition. Sixteen potters selected – the oldest, the late Bernard Leach; the youngest, Sara Radstone.

Attends the Banff Centre, School of Fine Arts, Alberta as a guest lecturer at their summer school.

'I've never demonstrated and I hope to die having never demonstrated. I don't believe watching me make a pot is going to give anybody anything, really. It's so simple and I don't think *how* it's done is what's interesting about it. When I went to teach at Banff I was the only guest who didn't give a big demonstration. I showed slides and talked and gave people tutorials and found out about their personal lives and how many times they'd married and why they had scars on their foreheads and they liked it. They said it was a refreshing change.'

1985 Solo exhibition in Japan. Lectures in Tokyo.

Visiting artist at the Ceramic Workcentre, Heusden, Holland.

Panel member at the Fourth International Ceramic Symposium, Toronto, Canada.

Alison Britton in Studio by Peter Dormer and David Cripps published.

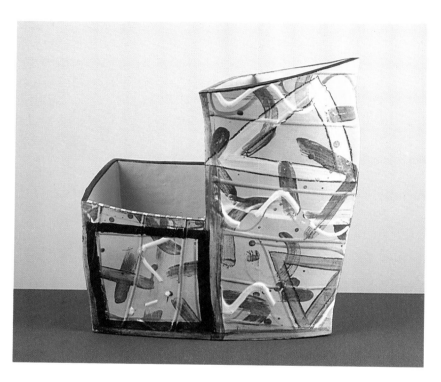

26. 'Square and Triangle, Turquoise and Brown'
1983 slab-built earthenware on a table by Floris
van den Broecke height approximately 33 cms

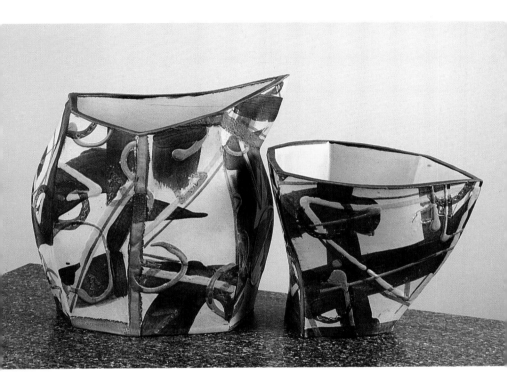

27. 'Blue Jug and Bowl' 1983 slab-built
earthenware on a table by Floris van den
Broecke jug height 28 cms
bowl height 20.4 cms

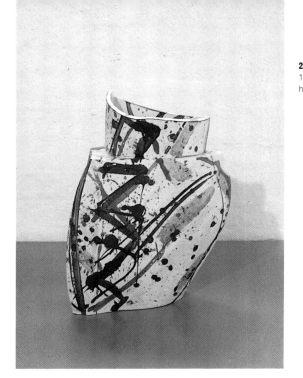

28. 'Black and White Pot'
1984 slab-built earthenware
height 40 cms

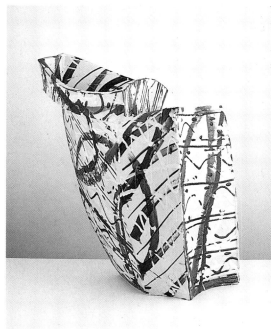

29. 'Black and White Pot'
1984 slab-built earthenware
height 40 cms

30. 'Black and White Pot' 1984 slab-built
earthenware height 42 cms

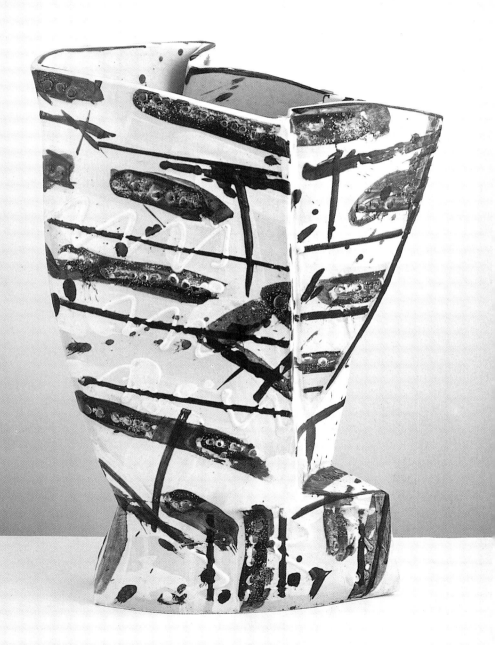

31. 'Dark Pair' 1985 slab-built earthenware
height 27 cms and 26 cms

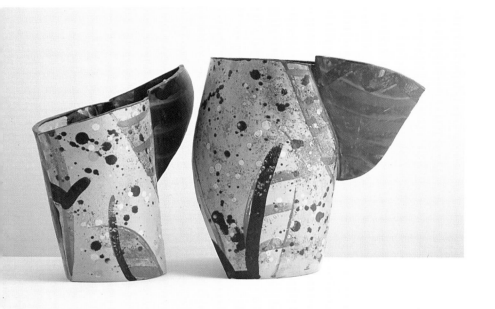

32. 'Standing Form' (front and back view) 1985
slab-built earthenware height 39 cms

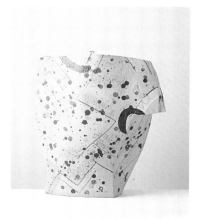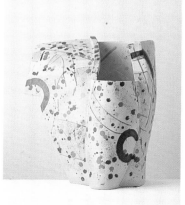

33. 'Standing Form, Brown Checks' 1985
slab-built earthenware height 41 cms

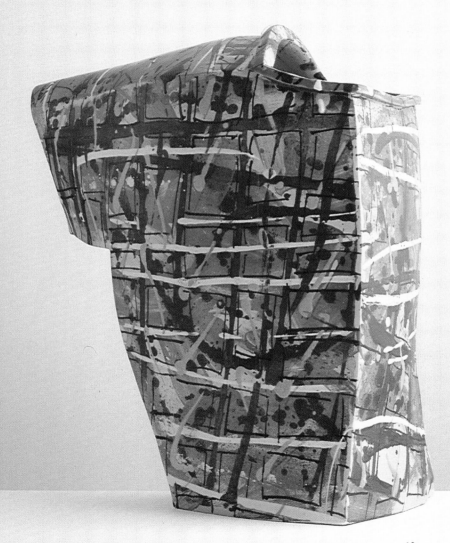

Contributes an essay and work to the ceramics exhibition *Fast Forward* organized by Peter Dormer and held at the Institute of Contemporary Art.

'It is rare that something made in ceramic can comfortably be described as sculpture. Sensible makers avoid the label. However elaborate or unusual a pot is in its form, the degree to which its existence hangs on "containing", actual or suggested, and on material qualities, disqualifies it from the broad concerns of sculptures' (Alison Britton, 'The Modern Pot', *Fast Forward*, ICI, 1985).

During the course of that year two friends, Jacqui Poncelet and Susanna Heron, decide to break all links with the craft world.

'One of the things I've wondered . . . I think you could look at what Jacqui Poncelet and Susanna Heron decided to do in a genderist light. I think they wanted to get further than a) women and b) people in the applied arts can get and they want to play the real game with the real rules in the big pond. And that's largely a male pond, isn't it? And Susanna has put aside all those wonderfully inventive things she did with bits of cloth, bits of paper, plastic, and is using bronze. Her last show was all bronze, which is absolutely in the middle of the main camp, isn't it? I thought it was sad to feel you've got to play with their rules, with their materials – before she was changing the rules. I think I look at them admiringly. I admire their courage. I think my own feelings go in two directions: one is that I can't imagine wanting to make something very different from what I'm making now. I think there's still a lot of material in this patch which goes on being interesting. I think I'm more interested in changing something from the inside, in actually staying where I am and saying, "But it can be this, or it can be that," rather than getting out and giving up. I do see it like a defection in a way. It's double-edged – I think they're wonderful and I admire them and like almost everything they do – on the one hand – and on the other hand I think it's a pity that this is the only step they think is worth taking.'

1986 Writes an introduction to Peter Dormer's *The New Ceramics*, quoting

from an inspirational text – John Shearman's *Mannerism:* 'It was common for Mannerist artists to adapt artistic forms or compositional devices, originally invented with expressive function, and to use them in a non-functional way, capriciously.'

Curates part of the exhibition *Our Domestic Landscape* at the Cornerhouse, Manchester, including pieces by Ewen Henderson, Jacqui Poncelet, Richard Slee and Betty Woodman.

Panel member at the symposium *American Potters Now* at the V&A.

Makes torsos for a figurative exhibition at the British Crafts Centre: 'The figurative pieces – some were too obvious and not three-dimensional enough. Some are trying too hard, the best are fairly oblique.'

1987 Takes part in *2D/3D: Art and Craft Made and Designed for the Twentieth Century,* held at Newcastle and at Sutherland. This was 'a celebration of art and craft set within a framework which deliberately disturbs the rigid compartments in which they are usually seen . . .' (John Millard and Tony Knipe, Introduction, *2D/3D: Art and Craft Made and Designed for the Twentieth Century,* Ceolfrith Press, 1987).

Writes a short piece in the catalogue: 'Pots that I have made have been *like* jugs (though some of them have *been* jugs) and recently like parts of the human figure. They continue to play with the gap between the first and second glance, in the belief that gaps are thrilling because the imagination must run into them at a moment of engagement with an object that hopefully shifts you temporarily out of the ordinary world. That is another kind of function.'

Solo exhibition at the former British Craft Centre, now strategically renamed Contemporary Applied Arts.

'It was a new studio and this was the first work that I made there. I knew I had nine months to work for the show and I was quite frightened starting again in a new place. And that is partly why it was so pared down to three colours – brown, white and blue – a very simple formula in a way. All the pieces were dark on one side and light on the other – a strong contrast of inside and out. Although it was well received there were some

45

34. 'Double Pot' 1987 slab-built earthenware
height 40 cms

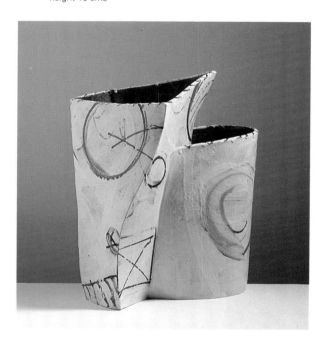

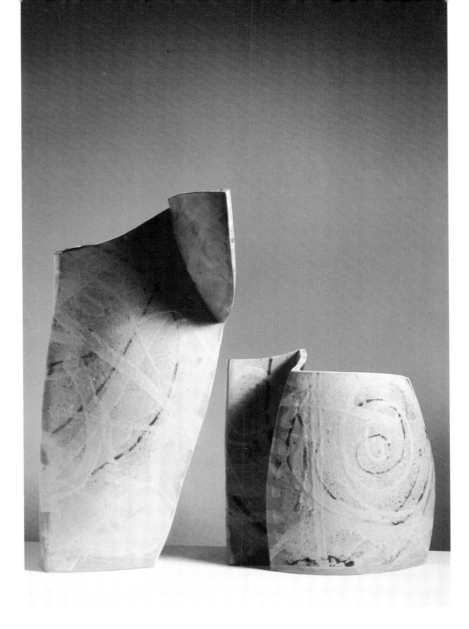

35. 'A Pair of Pots' 1987 slab-built earthenware
height 43 cms and 26 cms

quite safe wickets in that '87 show. Yes, the pot now in Hove Museum – I think it is the best of the double pots. It was made very near the beginning of that spate of work and I was asking myself what still has some meaning for me, what could I start on? It was probably the second or third piece I made. It is more sensual than most and because it is somehow introverted, because the lip/beak goes over the second chamber, it also has a curiously self-contained air.'

Takes part in the Gulbenkian-funded *Vessel Forum* in Birmingham in September. Shows with a mixed bag of painters, sculptors and potters in the Serpentine show *Vessel* organized by Anthony Stokes – 'a good first trawl'.

1988 An exhibition of Ed Wolf's collection of Alison Britton's pots at Parnham House, Dorset.

Solo exhibition at the Crafts Council of New South Wales, Sydney, Australia. Guest speaker at the World Craft Conference, Sydney, in May, lecturing at Melbourne, Canberra, Brisbane and Sydney art institutions.

1989 A small solo exhibition in the National Museum, Stockholm, Sweden.

'It now seems that there is something a little too flamboyant about using a slip trailer to decorate. It seems more mature to make a mark with greater control. A trailer is shakier, bolder and less committed than a brush. I might still be moving towards something that isn't painted on at all but I have not got there yet. I've certainly tried pieces that are monochrome, that just have some pattern in the texture. But I'd be loath to stop painting. I see it as one of the jobs that pottery can do and nothing else can do – that mixture of having a concern for the painted surface and having a concern for form. That is what is special about ceramics.'

1990 OBE in the New Year Honours List.

Solo show at Contemporary Applied Arts.

'*Identification (factual description of artefact), evaluation (compare with other objects), cultural analysis (relationship of artefact to its*

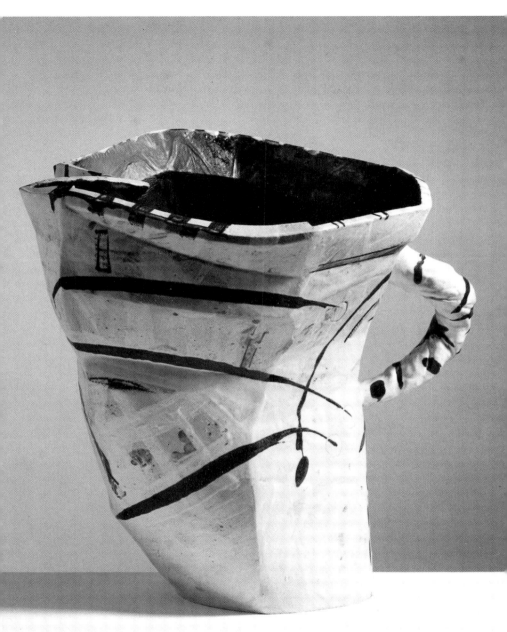

36. 'Big White Jug' 1987 slab-built earthenware height 42 cms

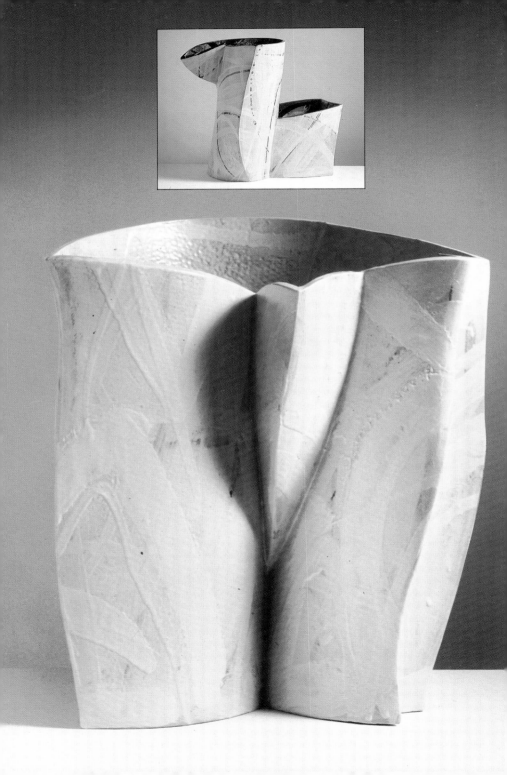

37. 'Double Pot, Brown and White' 1987
slab-built earthenware height 36 cms

39. 'Double Pot, Curve and Triangle' 1988
slab-built earthenware height 37 cms

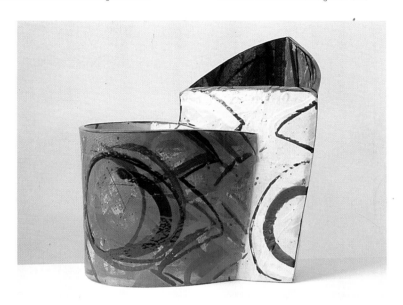

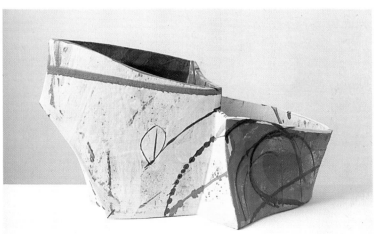

40. 'Low Double Pot' 1988 slab-built earthenware
height 29 cms

38. 'White Vessel' 1987 slab-built earthenware
height 31 cms

culture), interpretation (significance). This model analysis from the *Winterthur Portfolio*, the American decorative arts journal, can in theory be applied to any object from a Coke bottle to a Rembrandt.

'*Identification (factual description).* It is fairly easy to record the appearance of an electroplated tea service or a Chippendale chair. It is more problematic to describe in detail a large constructed sculpture or an abstract painting. We cannot convey the necessity to move around the sculpture; its multiplicity of viewpoints demands multiple descriptions. Equally the painting with its veils of colour, discrete marks and harmonious passages may tempt us into generalizations and away from straight description. In a similar way Alison Britton's work resists the cataloguer. It can be done – "tall earthenware inlaid slab-built jug form etc." – but the information usually fails to enlighten us. Similarly, photographs of her work tend to be misleading and drawings made as an *aide-mémoire* turn out to be curiously unhelpful.

'*Evaluation (compare with other objects).* This is easier. We might turn to other examples of studio ceramics. The largely unwritten history of studio ceramics has been dominated by an unimaginative reading of Bernard Leach's creative philosophy. By the late sixties many of Leach's admirers came to believe that he was primarily committed to making functional ware and that this was the proper work of the potter. Since then it has become usual to say that the work of Alison Britton and her contemporaries belongs to a much older tradition – of non-functional ceramics that have the status of treasure (to use Philip Rawson's phrase) and which tend to reflect the fine art of the period. Thus fifteenth century maiolica, eighteenth-century Meissen and Sèvres and nineteenth-century art pottery are all invoked to give context to the work of Alison Britton.

'Of course the mood and intention differs from these examples of high ornament. Alison Britton is probably the best decorator of ceramics working at present – the word decorator seems in fact misleading, while painter would be inaccurate. What actually goes on is a transformation and occasionally a salvage of the constructed shape. Part of the tension and strength of her work arises from the ways in which she puts together

awkward, even unlovely, shapes and then proceeds to transform them with lyrical brushwork and drawing.

'*Cultural analysis (relationship of artefact to its culture)*. Here we can safely observe that the culture does not quite know where to put this kind of work. Sometimes it is consumed as pure ornament. Thus dark pieces may be less popular than, for example, blue and white (a combination that has happy associations for the lover of ceramics). There is an element of democratization – sculpture for the home. Most of us recognize in Alison Britton's work a family of shapes – an echo of collar construction in metal or cloth, a hint of tubing, lots of bowls and jugs. Another audience, lovers of abstraction, formalists, will be drawn to her mark making. In that sense she belongs to the St Ives of painting while being distant from the St Ives of pottery.

'*Interpretation (significance)*. Some of these pots make their point quite simply – through beauty. They satisfy an inner rule of harmony in both shape and decoration. I suspect that Alison Britton could produce whole sequences of such harmonious work. But she is equally drawn to awkwardness. The creation of problematic shapes is not the usual business of the applied artist or decorative artist. Their task, we are quite rightly told, is to provide solace for the domestic environment. The pots in this exhibition are giving us something rather different. At the end of the post-modern decade, during which art has turned to irony and quotation, we are getting a refreshing glimpse of modern artist at work' (from *Alison Britton* – a leaflet written by Tanya Harrod for Contemporary Applied Arts).

'I experienced the first wave of feminism at the Royal College, imbibing it all and it being fresh and exciting. I think I've been living it since then and I have had maturer reflections about it. Early on I felt that it was dangerous to discuss my work in terms of feminism. A lot of art was being made at the time that was more content than form and I've never felt attracted to an art in which the message dominates its formal qualities. For instance, I wasn't drawn to see Judy Chicago's *Dinner Party*. I think I regret it now, but there were things I could see from photographs

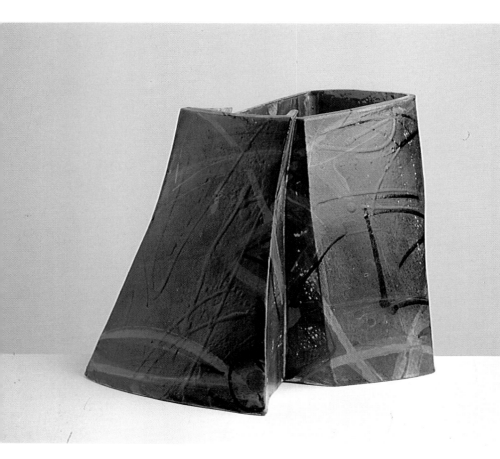

41. 'Blue Apron Fronted Pot' 1988 slab-built
earthenware height 31 cms

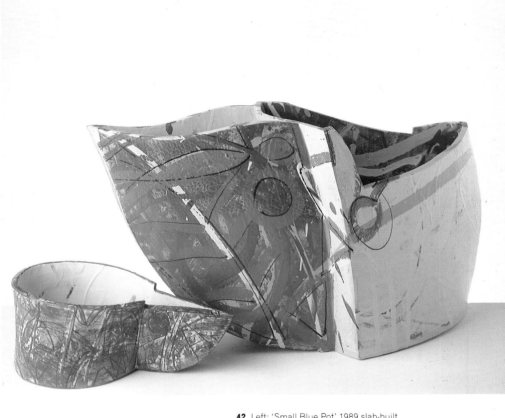

42. Left: 'Small Blue Pot' 1989 slab-built
earthenware height 11 cms. Right: 'Double Pot
with Spout' 1988 slab-built earthenware height
31 cms

about its visual constituents that weren't good enough. I used to say that pottery is within the grasp of women; it's not that difficult to do and there is no big deal about doing it, unlike steel smelting or something. And I didn't feel I was particularly a woman potter. I was a potter. I still say that, but there was something eye-opening about reading Cheryl Buckley's book [*Potters and Paintresses: Women Designers in the Pottery Industry 1870–1955*, The Women's Press, 1990] and seeing where women had been all the way through. There are things in that book that have changed me permanently, I think. I was very struck by her point that men were traditionally in charge of the shape of pottery in the factories and women were allowed only to decorate the shape afterwards. That is really potent, isn't it? The only way women could get any status at all was if they were very good at putting things on the surface. And that was my avenue at the Central and at the College: I was thought of as a decorator, as an imaginative surface person. And now I make the shape and that rules everything. And I regard that as a transition into something stronger.'

43. 'Big Pot with Collar' 1990 slab-built earthenware height 42 cms

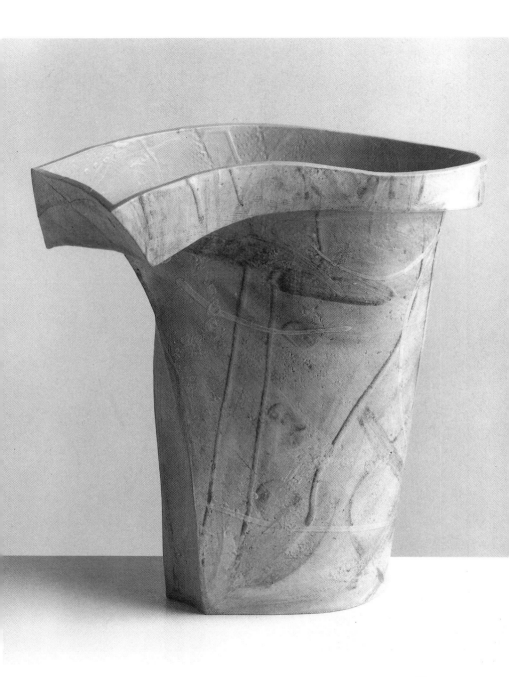

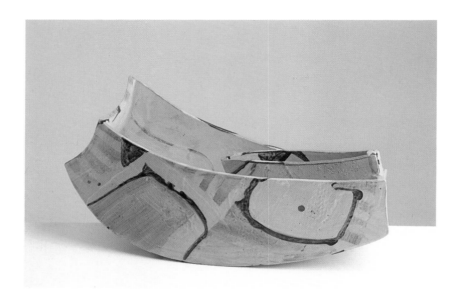

44. 'Pink dish' 1990 slab-built earthenware
length 38 cms

45. 'Blue and Yellow Pot' 1990 slab-built
earthenware height 35 cms

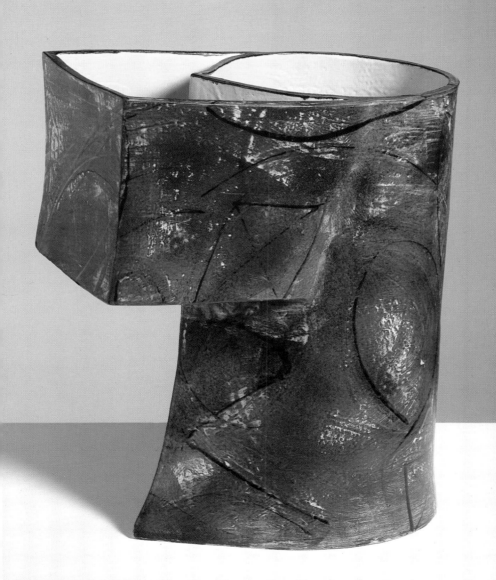

Exhibitions

1970 Forum Gallery, Brighton
1976 Amalgam Gallery, Barnes, London
 (solo)
1977 **Ceramics and Textiles,** British
 Council touring exhibition (Middle
 East)
1978 Galerie het Kapelhuis,
 Amersfoort, Netherlands; with
 Jacqui Poncelet
 Five British Potters,
 Princessehoff Museum,
 Leeuarden, Netherlands
1979 **Jugs and Aprons,** Aberdeen Art
 Gallery & Museum; with
 Stephanie Bergman
 Prescote Gallery, at Warwick
 House, London
 Image & Idea, British Council
 touring exhibition (Australia &
 New Zealand)
 The Work of Alison Britton,
 (solo) Crafts Council, London
1980 **British Ceramics Today,** Octagon
 Center, Ames, Iowa, USA (and tour)
 Ceramic Summer, Sudbury Hall,
 Derbyshire
 Edinburgh Festival (Prescote at
 Edinburgh)
 Galerie het Kapelhuis, Amersfoort
 and Museum het Kruithuis,
 s'Hertogenbosch, Netherlands;
 with Jacqui Poncelet
 Image & Idea, British Council
 touring exhibition (Australia &
 New Zealand)
1981 Prescote Gallery, Banbury, Oxon
 (solo)
 British Ceramics & Textiles,
 Scharpoord Cultural Centre,
 Knokke-Heist, Belgium
 Victoria & Albert Museum,
 Craft Shop, London (solo)
1982 Galerie L, Hamburg; with
 Jacqui Poncelet
 The Maker's Eye, Crafts Council
 Gallery, London (artist was also
 one of fourteen selectors)

Victoria & Albert Museum, Craft
Shop, London (solo)
Amalgam Gallery, London; with
Jacqui Poncelet and Noela Hills
Scottish Gallery, Edinburgh
(organised by Henry Rothschild)
Eckenfode, Germany (organised
by Henry Rothschild)
1983 **British Ceramics & Glass,**
 Convergence Gallery, New York
 (part of 'Britain Salutes New York'
 festival)
 Fifty Five Pots, Orchard Gallery,
 Londonderry, Northern Ireland
 Galerie het Kapelhuis,
 Amersfoort, Netherlands; with
 Jacqui Poncelet and Walter Keeler
 Pots and Tables, Aspects Gallery,
 London; with Floris van den
 Broecke
 Oxford Gallery, Oxford;
 with Brian Illsley
1984 Galerie L, Hamburg; International
 group exhibition
 Westminster Gallery, Boston, USA;
 with Jacqui Poncelet
 Artist Potters Now, Oxford
 Museum, and tour
 Maya Behn Gallery, Zurich,
 Switzerland; British group
 exhibition
 Black and White, British Crafts
 Centre, London
 British Ceramics, British
 Council touring exhibition
 (Czechoslovakia); curated by
 the artist
 Aspects of Art, Aspects Gallery,
 London, and tour
1985 Miharudo Gallery, Tokyo, Japan
 (solo)
 **Fast Forward; new directions in
 British ceramics,** ICA, London;
 curated by Peter Dormer
 Galerie het Kapelhuis,
 Amersfoort, Netherlands; with
 Jacqui Poncelet, Richard Slee,
 Carol McNicoll

Museum het Kruithuis, s'Hertogenbosch, Netherlands
Fitzwilliam Museum, Cambridge (organised by Henry Rothschild)
Craft Matters, John Hansard Gallery, Southampton University
Dragonstone – innovations in Clay, Art Gallery at Harbourfront, Toronto, Canada; ten international artists

1986 Dorothy Weiss Gallery, San Fransisco, USA
British Design, Kunstlerhaus, Vienna, Austria; curated by Peter Dormer (part of 'Britain in Vienna' festival)
Kunstformen Jetzt, Salzburg, Austria; British Ceramic Artists
British Crafts Centre, London; Figurative exhibition
International Contemporary Art Fair, Olympia, London; represented by British Crafts Centre
'Jahresmesse', Museum fur Kunst und Gewerbe, Hamburg, Germany
Aspects Gallery, London; launch exhibition for publication of Thames & Hudson book *The New Ceramics*
Our Domestic Landscape, Cornerhouse Gallery, Manchester, and tour

1987 **2D/3D : Art & Craft Made and Designed for the Twentieth Century,** Laing Art Gallery, Newcastle-upon-Tyne, and Northern Centre for Contemporary Art
Ceramisti Inglesi a Bassano, Palazzo Agostirelli, Bassano del Grappo, Italy; six British ceramicists
Alison Britton – new ceramics, Contemporary Applied Arts, London

1988 **British Ceramics,** Garth Clarke Gallery, Los Angeles, USA

Crafts Council of New South Wales, Sydney, Australia (solo)
Parnham House, Dorset; work by the artist from the collection of Ed Wolfe
Sotheby's, London; Decorative Arts Award exhibition
Celebrity Crafts, Usher Gallery, Lincoln
International New Art Forms Exposition, Navy Pier, Chicago, USA; artist and Brian Illsley represented by Contemporary Applied Arts
National Museum of Modern Art, Kyoto and National Museum of Modern Art, Tokyo, Japan; contemporary British craft exhibition organised by British Council
Galerie het Kapelhuis, Amersfoort, Netherlands; with Robert Marsden and Maria van Kesteren.

1989 Galerie L, Hamburg, Germany; with Janice Tchalenko
Keramik aus England, Sandhausen and Munich, Germany
L'Europe des Ceramistes L'Abbaye Saint Germain d'Auxerre, France
5ème Biennale de Ceramique Contemporaine, Musée Bertrand, Chateauroux, France
Off the Wheel; a new look at modern British pottery, Whitworth Art Gallery, University of Manchester
Out of the Wood, Crafts Council, with Common Ground, London
National Museum, Stockholm, Sweden (solo)

1990 Contemporary Applied Arts, London (solo)
Aberystwyth Arts Centre, and tour (solo restrospective)

Publications

1976 **Public and Private,**
 Marigold Coleman, *Crafts* No 21
 July/August
1977 **The Craft of the Potter,** Michael
 Casson, BBC Publications
 Ceramics and Textiles,
 John Houston, British Council
1979 **The Work of Alison Britton,**
 catalogue, Crafts Council
 Juggling into Jugs,
 Elizabeth Fritsch, *Crafts* No 41
 November/December
 Alison Britton: playing with clay,
 John Russell Taylor,
 Ceramic Review No 60
 Pots and Shoes and Things,
 John Russel Taylor,
 Antiques Weekly, December
 Putting the Boot On,
 William Packer, *Financial Times,*
 8 December
1980 **Jugular Vein,** Lesley Adamson,
 Guardian, 5 January
 The Decorated Tile, J.&B.
 Austwick, Pitman Publishing
 **British Twentieth Century
 Studio Ceramics,** Ian Bennett;
 Christopher Wood Gallery, London
 Image and Idea, catalogue,
 John Houston, British Council
1981 **British Ceramics & Textiles,**
 catalogue, British Council/Crafts
 Advisory Committee, Knokke
 Heist, Belgium
1982 **The Maker's Eye,** catalogue,
 Crafts Council, London
 The Case for Crafts,
 William Packer, *Financial Times,*
 19 January
 **Ceramics of the Twentieth
 Century,** Tamara Preaud and
 Serge Gauthier, Phaidon Press
1983 **Fifty Five Pots,** catalogue, with
 contributions by Peter Dormer,
 Peter Fuller and Martina Margetts,
 Orchard Gallery, Londonderry

Aspects Gallery, leaflet, article by
Peter Dormer
A Doodle or a Masterpiece, Nigel
Wigmore, *Guardian,* 14 October
Jouer l'objet; *L'Atelier des
metiers d'Art* No 76
1984 **Artist Potters Now,** catalogue,
 Susan O'Reilly, Oxfordshire
 County Museums Service
1985 **British Ceramics,** catalogue,
 Museum het Kruithuis,
 s'Hertogenbosch, Netherlands
1985 **Alison Britton in Studio,** Peter
 Dormer, photography by David
 Cripps, Bellew Publishing, London
 **British Ceramics in a
 Czechoslovak Venue,** Milena
 Lamarova, *American Craft* 45/1
 February/March
 Art into Object, Tanya Harrod,
 Craft Matters catalogue, John
 Hansard Gallery, Southampton
1986 **Britain in Vienna,** catalogue, CO1
 London/Kunstlerhaus, Vienna
1987 **Inglesi Ceramisti a Bassano,**
 catalogue, Bassano del Grappa,
 Italy
 Alison Britton, Angus Suttie,
 Ceramic Review No 107
 September/October
 Pots of Provocation, Rosemary
 Hill, *Guardian,* 9 September
 **Putting Potters in Their Proper
 Place,** William Packer, *Financial
 Times,* 15 September
 The Dangers of Vesselism,
 Tanya Harrod, *The Spectator,*
 9 September
1988 **Alison Britton,** Wendy Bubin,
 American Ceramics 7/1
 Liberation of the Jug, Oliver
 Watson, *Craft Arts* No 12 May/July
 Contemporary British Craft,
 catalogue introduction by Martina
 Margetts, British Council
 Alison Britton – new work,
 Peter Dormer and Tanya Harrod,
 Crafts No 90, January/February

1989	**Off the Wheel; a new look at modern British pottery,** catalogue, Whitworth Art Gallery, Manchester **British Design; image and identity,** Frederique Huygen, Boymans van Beuningen Museum, Thames & Hudson **Cinquième Biennale de Chateauroux,** catalogue, Peter Dormer, Musée Bertrand, Chateauroux
1990	**Alison Britton,** William Packer, *Crafts* No 105 July/August

Writings by the Artist

1978	**Pots about Music,** catalogue on Elizabeth Fritsch; Leeds City Art gallery for Temple Newsam House
1983	**Sèvres with Krazy Kat,** *Crafts* No 61 March/April
1984	**Hans Coper 1920 – 1981,** *American Craft* Vol 44 No 2 April/May **Stephanie Bergman, work on canvas, designed & painted,** Crafts Council **New Domestic Pottery,** catalogue, Crafts Council **British Ceramics,** catalogue introduction, Ministry of Culture, Bratislava, Czechoslovakia
1984–6	for British Craft Centre; exhibition leaflets on various craft subjects **British Ceramics,** catalogue introduction, Freemantle Arts Center, USA
1985	**The Modern Pot,** essay in 'Fast Forward' catalogue, ICA publications **Taking up the Chair,** on Floris van den Broecke, *Crafts No 76* September/October
1986	**American Potters Today,** *Ceramics* May/June **The New Ceramics,** introduction, Thames & Hudson

Our Domestic Landscape, catalogue essay, Cornerhouse, Manchester
2D/3D: Art & Craft Made and Designed for the Twentieth Century, catalogue essay, Laing Art Gallery, Newcastle
Eastern Approaches, on the opening of a new Japanese gallery in the Victoria & Albert Museum, *Crafts* No 83 November/December

1987	**David Garland,** Crafts Council
1987–90	for Contemporary Applied Arts, London (formerly British Crafts Centre) exhibition leaflets on various crafts subjects
1989	**Taking the Initiative,** report on Gulbenkian Foundation Vessel Workshops, *Crafts* No 97 March/April **The Critic's Eye** on Ken Eastman, *Crafts* No 98 May/June **Jim Partridge, Woodworker,** catalogue essay, Crafts Council **Glassworks, London,** *Neues Glas* No 3 September

Collections

Photographic Credits